An Indian Coloring Book

Tinka

A day in a little girl's life

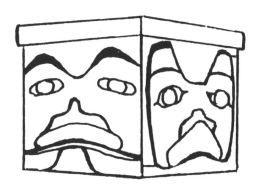

by Carol Batdorf

hancock house

ISBN 0-88839-249-4
Copyright © 1990 Carol Batdorf

Second printing 2005

An Indian Coloring Book
TINKA
A day in a little girl's life

by Carol Batdorf

Printed in South Korea—PACOM

Published simultaneously in Canada and the United States by

HANCOCK HOUSE PUBLISHERS LTD.
19313 Zero Avenue, Surrey, B.C. Canada V3S 9R9

HANCOCK HOUSE PUBLISHERS
1431 Harrison Avenue, Blaine, WA, USA 98230-5005

(604) 538-1114 Fax (604) 538-2262
(800) 938-1114 Fax (800) 983-2262

Web Site: www.hancockhouse.com
Email: sales@hancockhouse.com

This is a story about a little Indian girl who lived long ago in a village on the northwest coast of North America. Her people built houses of cedar wood. They gathered food from the sea, the beaches, and the forests. The men made canoes big enough to sail on the rough ocean waters. They carved huge totem poles to record special events. The women wove baskets and made clothes of cedar bark, wool, and leather. Everyone had work to do.

The children had work, too. They needed to learn how all things that the people used were made and they had to find out how to get food to eat. There were no schools, so they learned by helping their elders and doing as they did.

The boys practiced fishing and hunting. They made small bows and arrows and tried to shoot squirrels and birds. When a boy killed his first small creature the people would praise him and say, "He will be a great hunter."

A girl needed to know how to make baskets and clothing and to smoke fish and clams for winter. After she had finished her first basket all the people were called to see it. "She is becoming a woman," they said. "Some day she will be a great basket maker. Everyone will respect her."

Boys and girls had fun while they learned. They practiced until they could swim like the otters. They spent hours splashing and playing games in the water. On the land they played tug-of-war to build strong muscles. They played games with sticks and stones to help them become fast and tough. They played hide-and-seek to sharpen their eyes and ears. There were lessons in everything they did.

The girl in the story, Tinka, learned many things in just one day. When you color the pictures, you can learn, too, just as she did. Since there is a lot of detail in the pictures, you might want to use felt pens or even colored pencils instead of crayons. Most importantly, have fun!

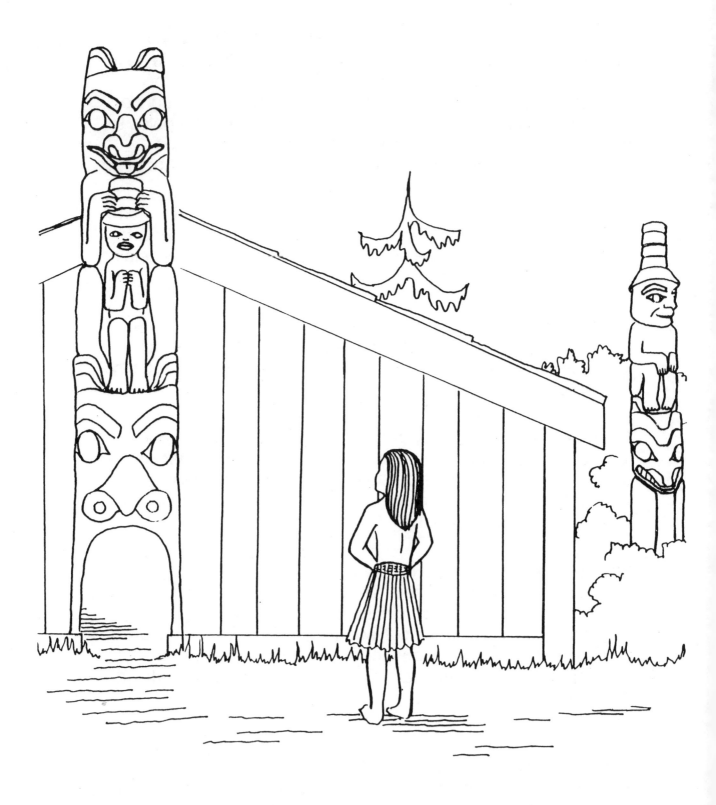

This is Tinka's house. The totem poles tell about her people. The house and the poles are made from the wood of cedar trees.

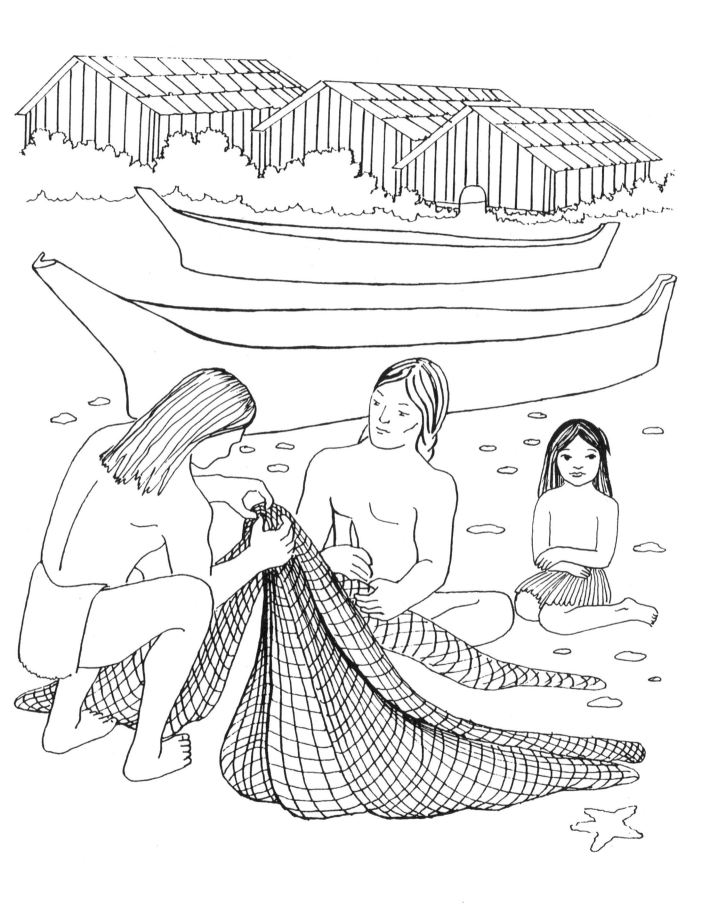

Tinka liked to watch her father and uncle mend their nets on the beach near the village.

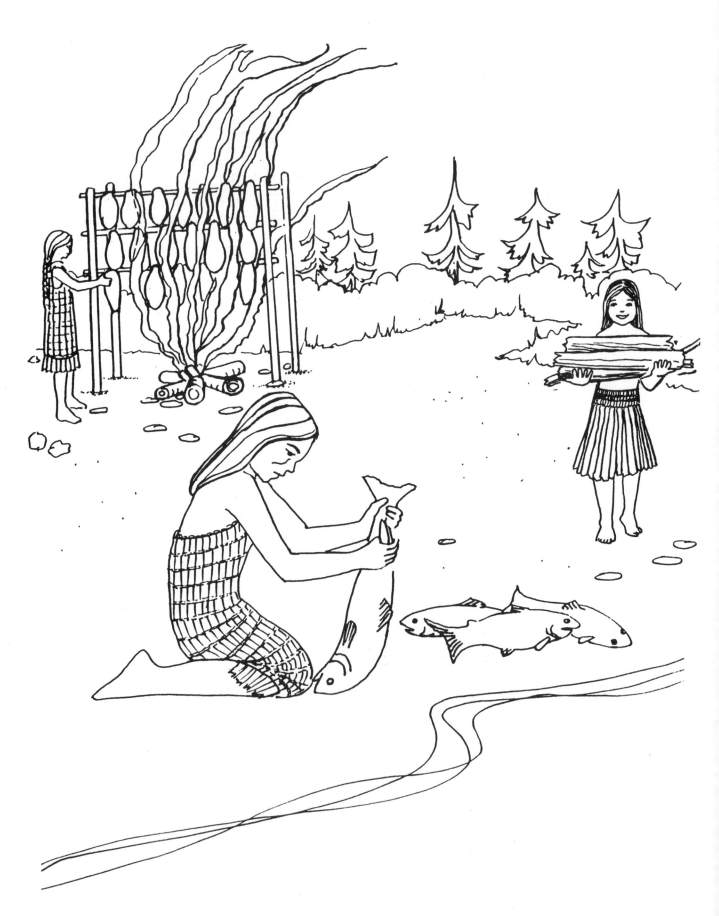

Sometimes she helped her mother and aunt clean and dry fish to eat in the winter time.

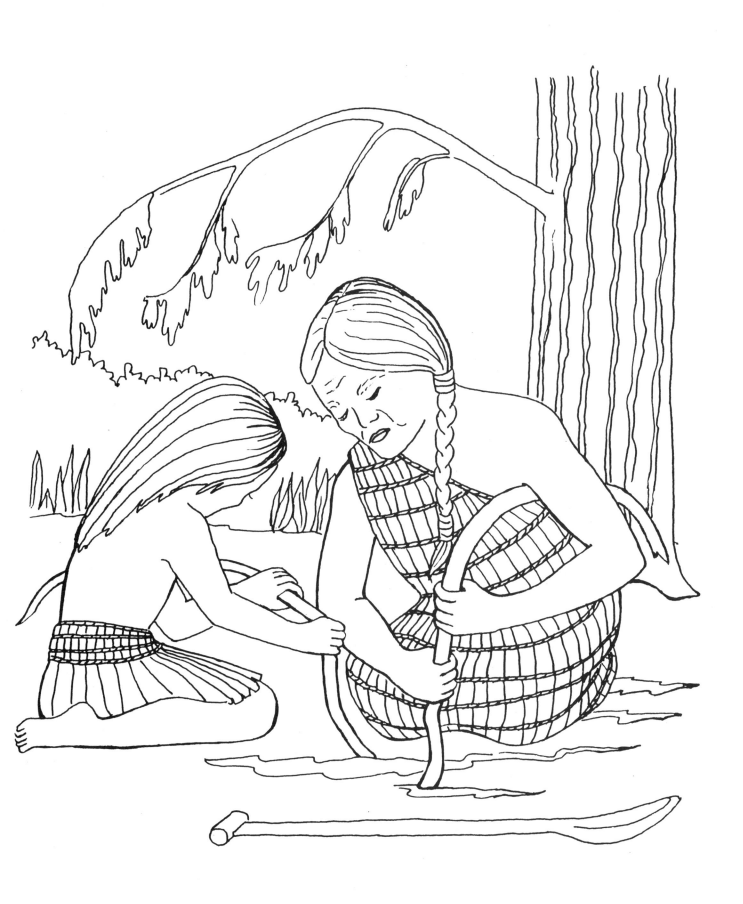

Other times she helped her grandmother gather roots for making baskets.

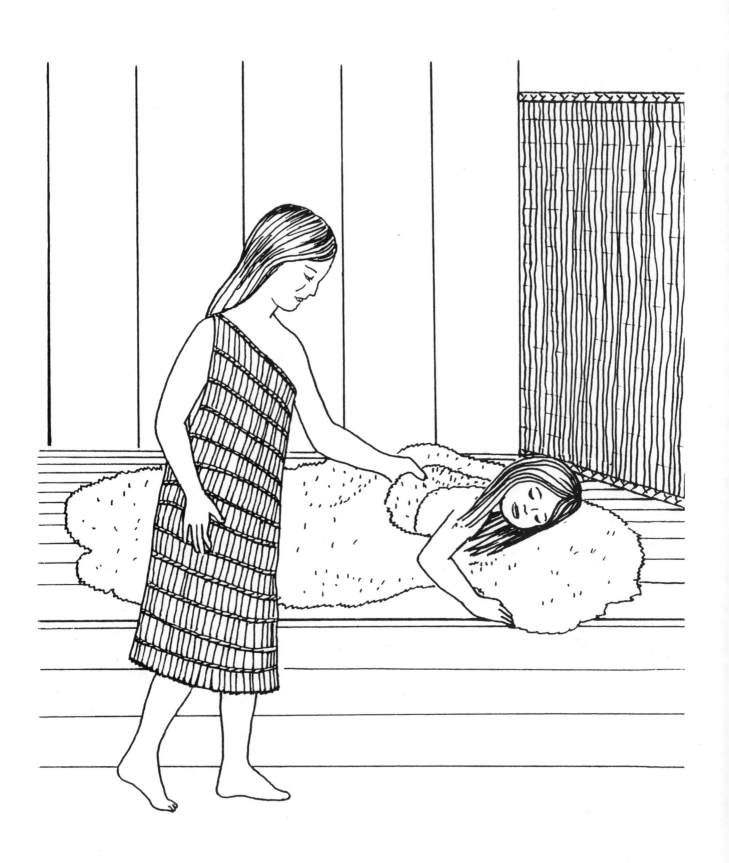

One morning her mother woke Tinka early. "Come," she said, "The tide is low. We will dig clams."

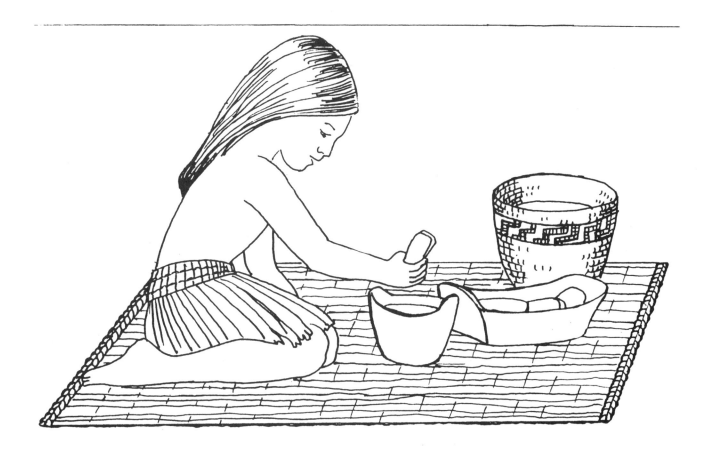

Tinka jumped out of her bed and ate a breakfast of dried salmon dipped in fish oil.

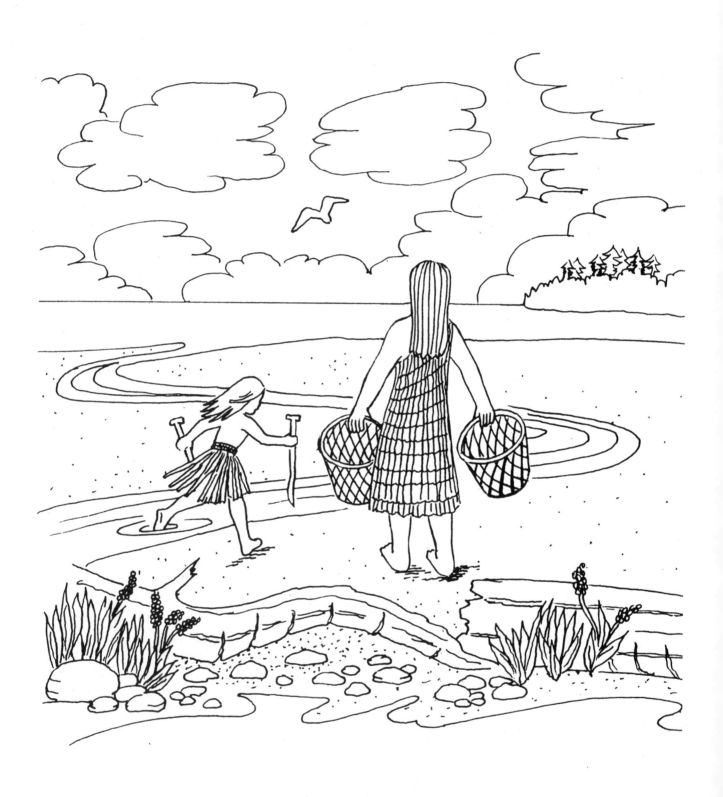

Then she and her mother took clam baskets and digging sticks and went to the tide flats.

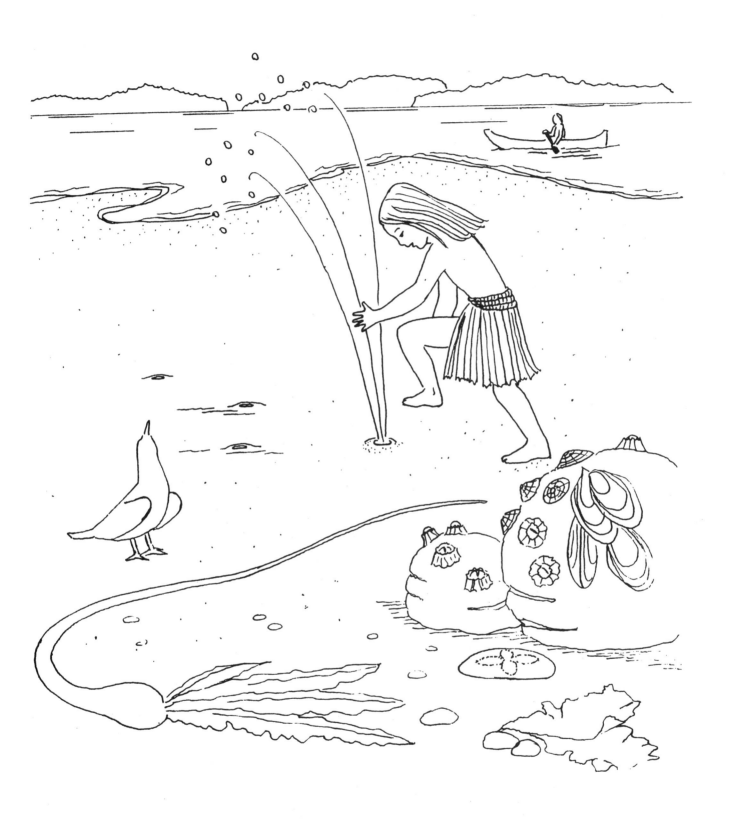

The sand was warm under Tinka's feet. She stomped clam holes to make them squirt.

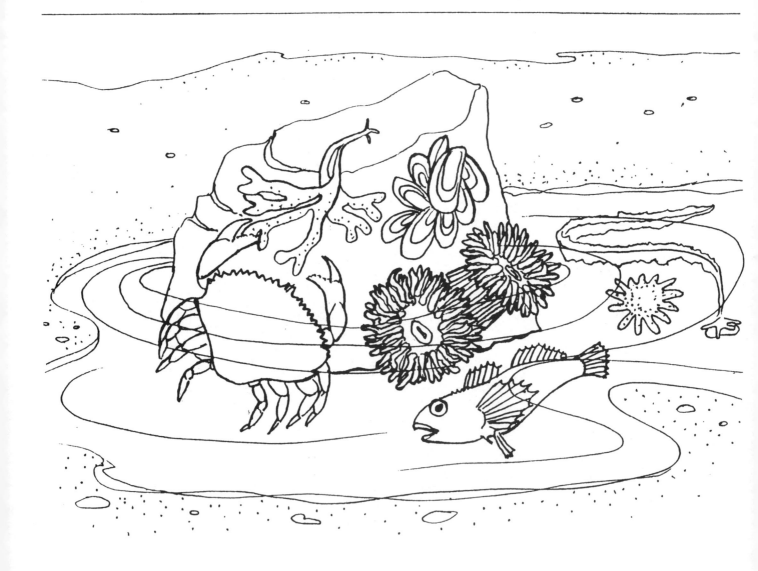

Then she stopped to watch the sea animals in the tidepools. There were anemones that looked like flowers under the water. There were bullheads swimming about and sand dollars

COLOR AND CUT OUT SECTION

These next eight pages can be removed—lift up center staples and remove sheets, then press staples back in place.

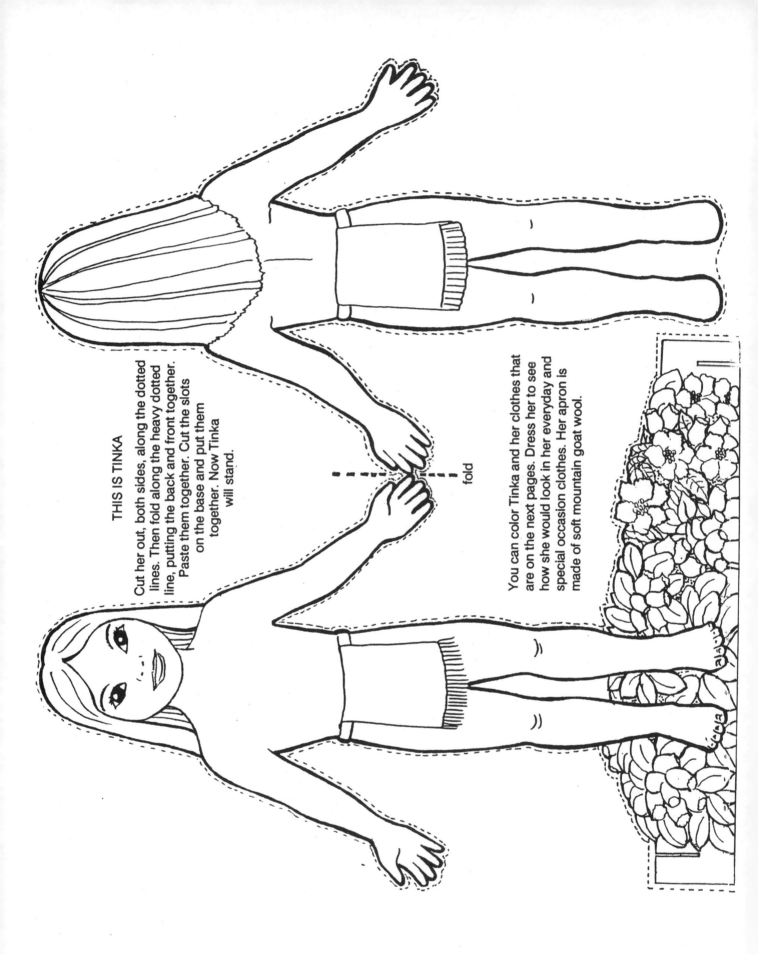

THIS IS TINKA

Cut her out, both sides, along the dotted lines. Then fold along the heavy dotted line, putting the back and front together. Paste them together. Cut the slots on the base and put them together. Now Tinka will stand.

You can color Tinka and her clothes that are on the next pages. Dress her to see how she would look in her everyday and special occasion clothes. Her apron is made of soft mountain goat wool.

fold

This is Tinka. She lived long ago in an Indian village on the northwest coast of the Pacific Ocean. You can color her and cut her out. She has a back, too. If you bend her stand and put the slots together, or paste them, she will stand.

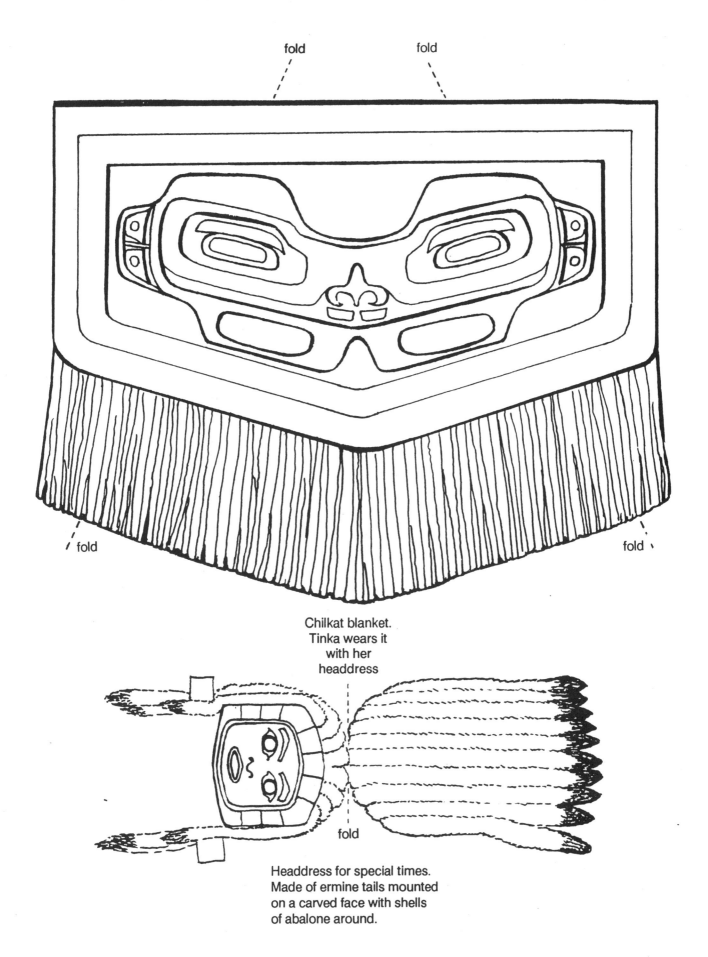

fold fold

fold fold

Chilkat blanket.
Tinka wears it
with her
headdress

fold

Headdress for special times.
Made of ermine tails mounted
on a carved face with shells
of abalone around.

These are Tinka's clothes. Color them and fold them to fit her. Then you can see how Indian girls dressed many years ago.

Back of cut out

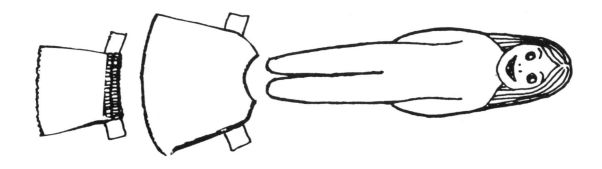

On this side you can create your own dress
patterns and then color them. Perhaps this
was a fur cap or perhaps you created Tinka
a copy of your favorite dress.

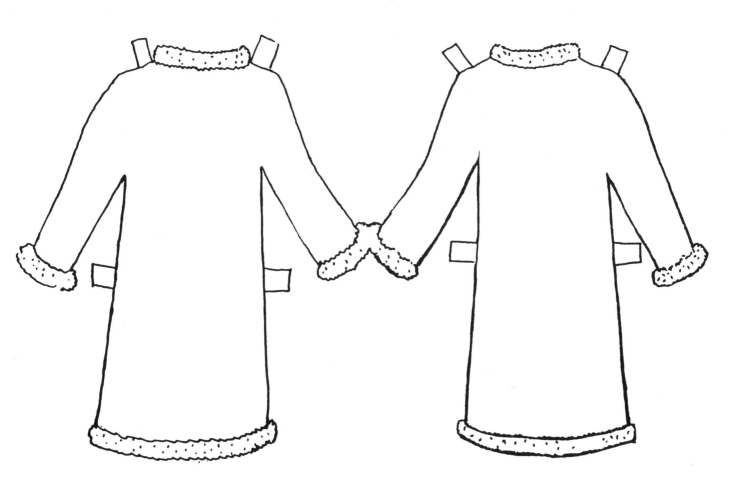

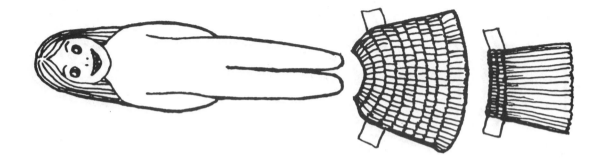

This is Kawaki. If you will fold Tinka's arms, she will hold Kawaki.

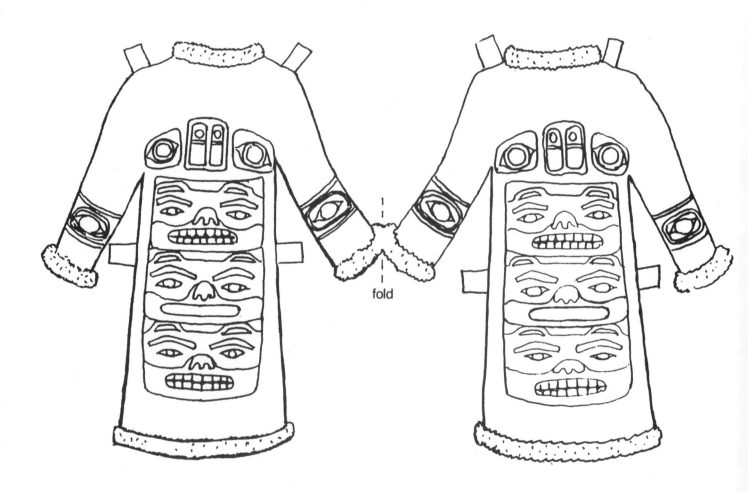

fold

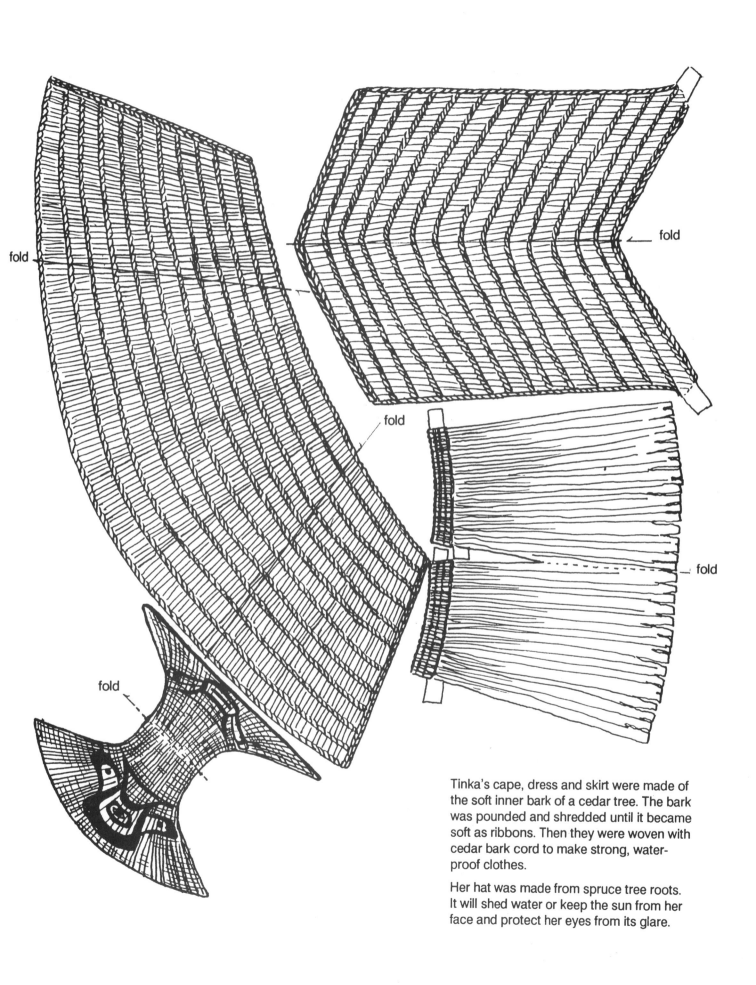

fold

fold

fold

fold

fold

Tinka's cape, dress and skirt were made of the soft inner bark of a cedar tree. The bark was pounded and shredded until it became soft as ribbons. Then they were woven with cedar bark cord to make strong, water-proof clothes.

Her hat was made from spruce tree roots. It will shed water or keep the sun from her face and protect her eyes from its glare.

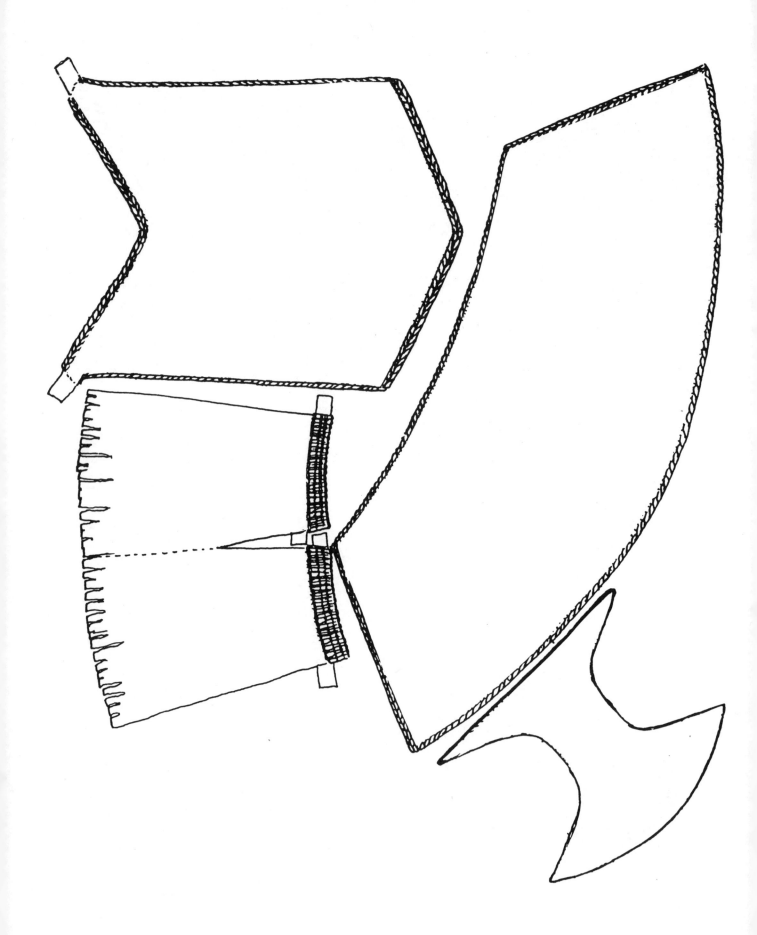

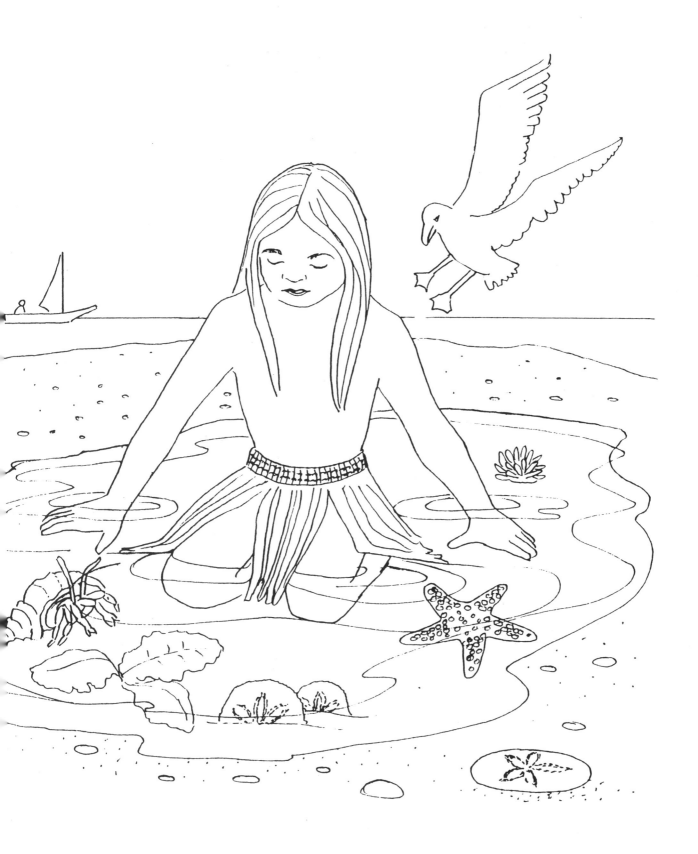

and crabs, even strange hermit crabs. On the rocks she found barnacles and limpets and blue mussels.

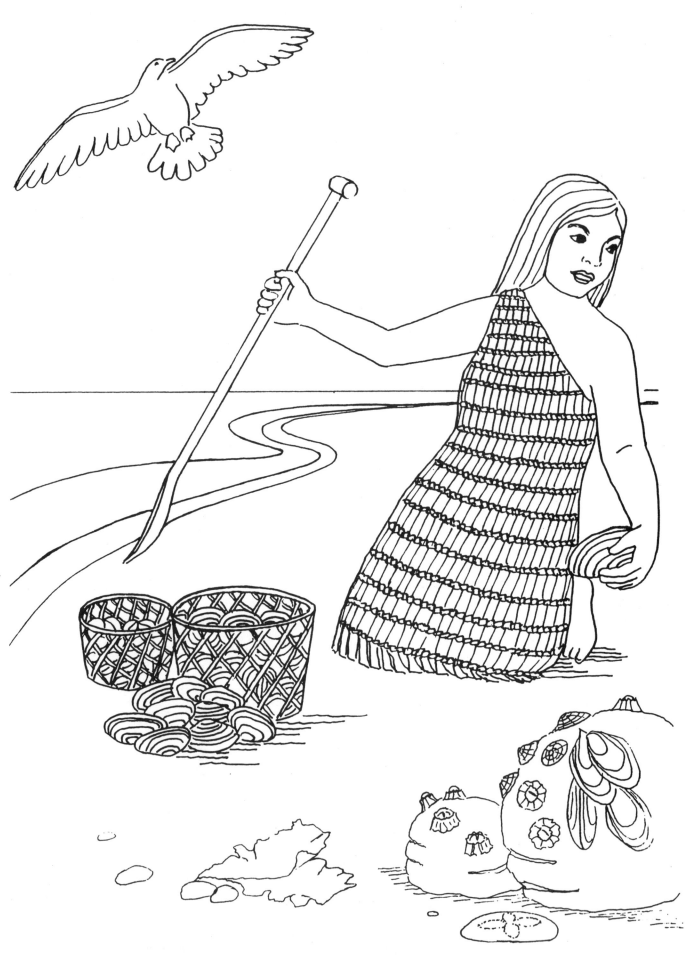

Her mother called to her, "Come and help me dig clams."

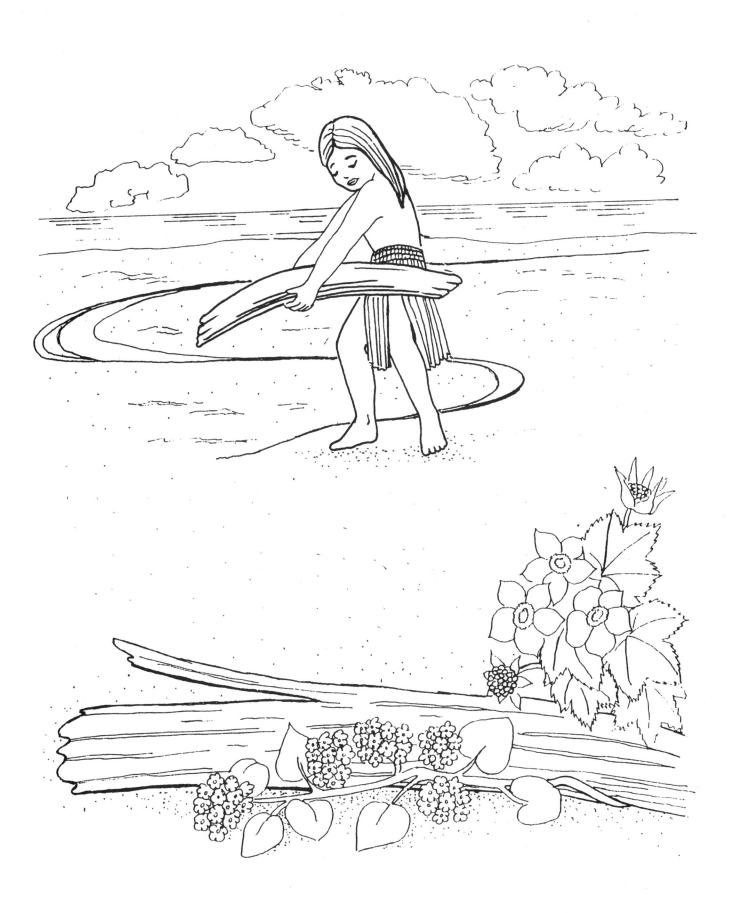

Suddenly she spied a whale bone lying on the sand. Tinka ran toward her mother.

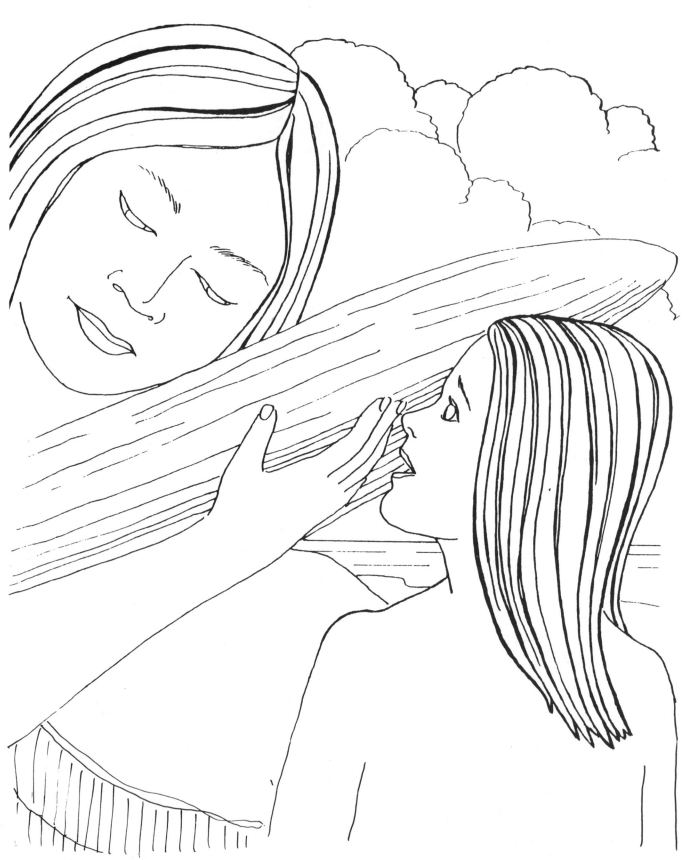

She showed it to her mother. "It is beautiful," mother said. "What will you do with it?" "Give it to Grandfather," Tinka answered.

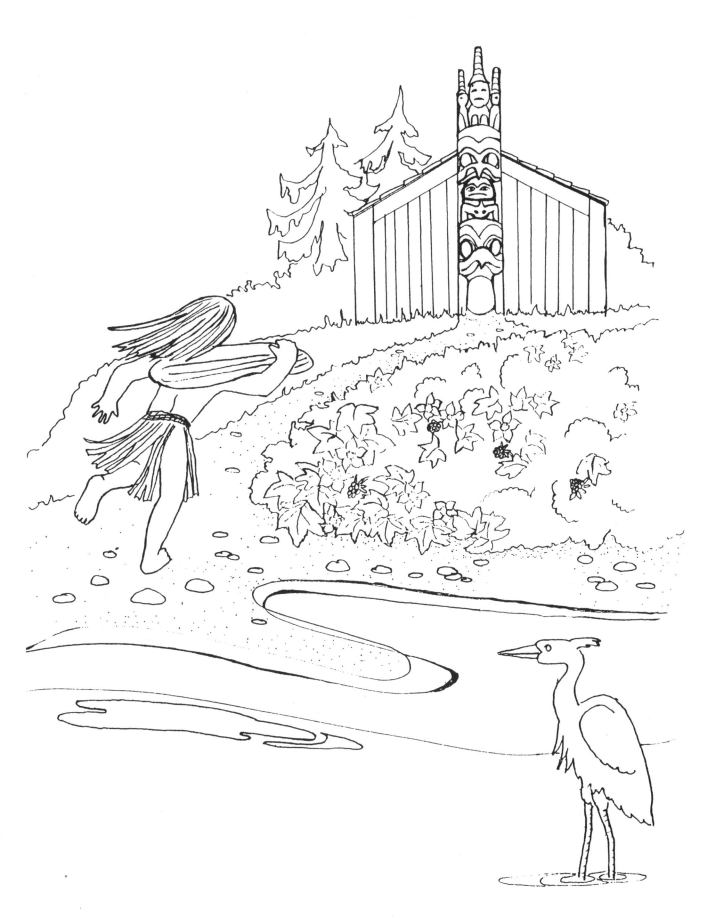

Tinka ran back to the village to find her grandfather.

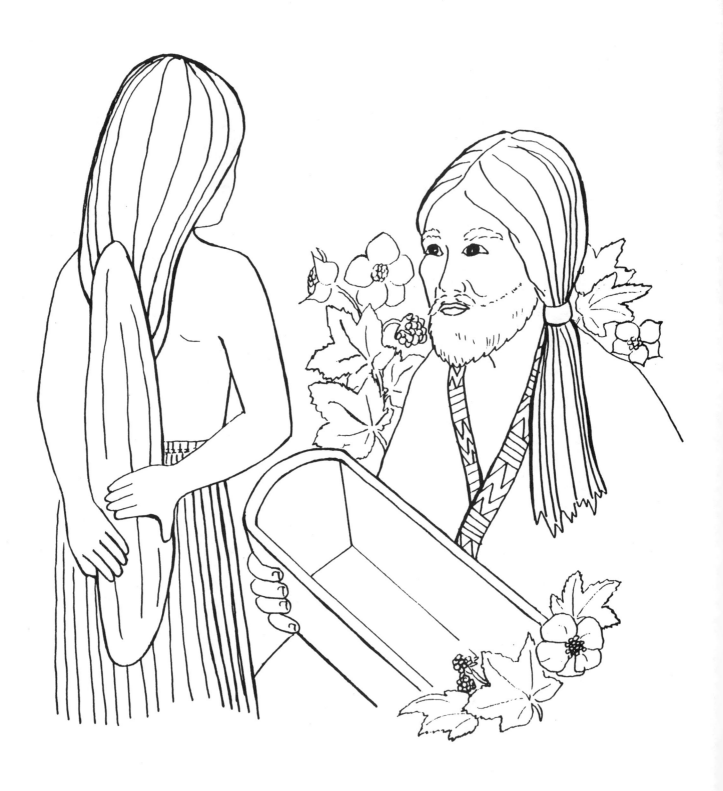

She found him sitting in the sun carving a food tray. He was pleased when she gave him the whale bone. "What will you make from it?" Tinka asked. "Wait and see," grandfather answered, smiling.

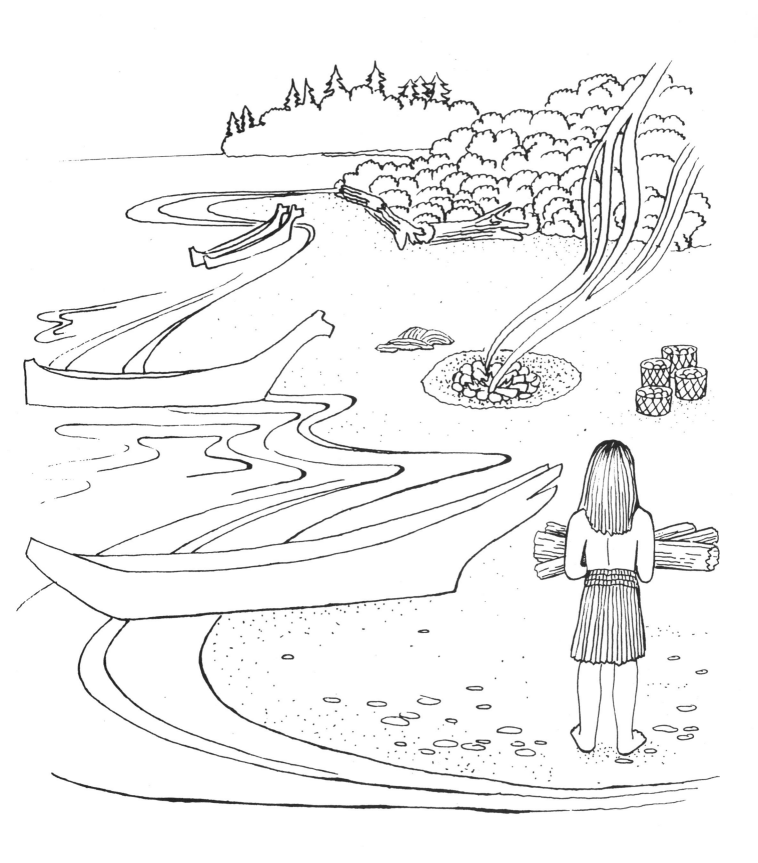

All the rest of the day Tinka helped her mother. She dug clams until Mother said they had enough. Then she dug a fire pit on the beach. She brought fire wood and gathered seaweed so they could cook the clams.

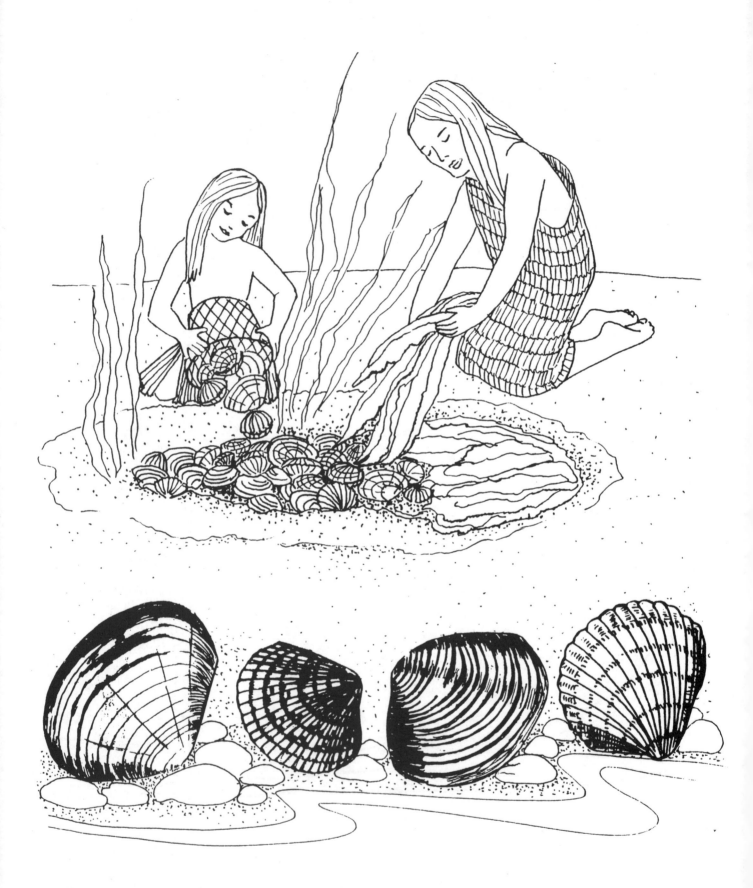

They built a fire in the pit. After the fire had burned down they laid seaweed on the hot coals. Then Tinka and her mother dumped the clams on top of the seaweed and put more seaweed over them. They put sand over it all so that the clams would steam and cook.

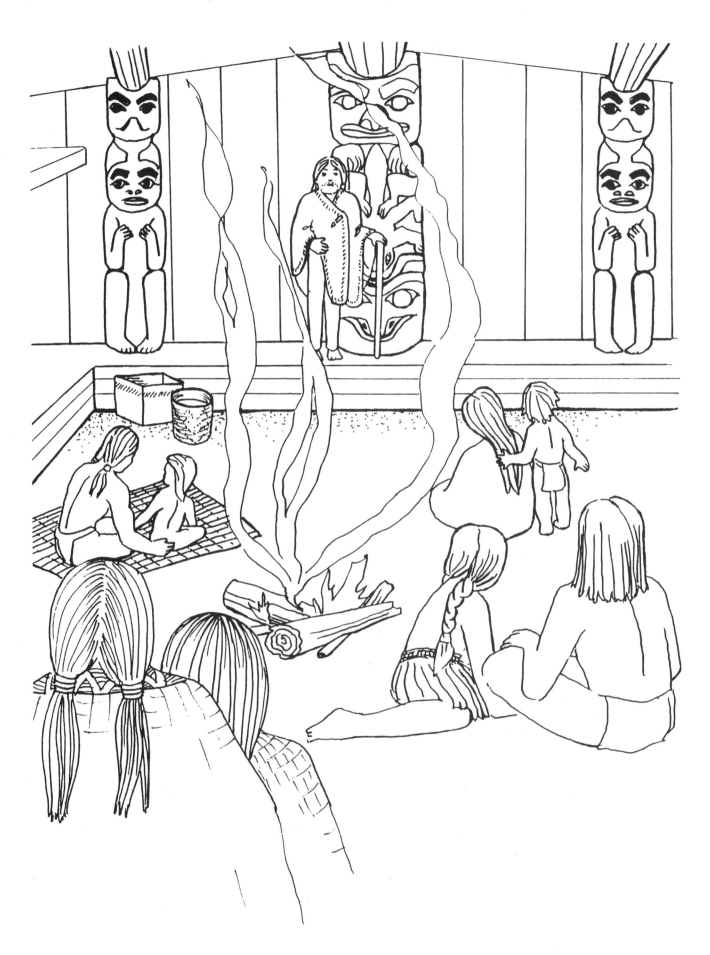

That night in the longhouse Grandfather told the people, "The sea has been good to us this day. Tonight we will feast on fresh clams."

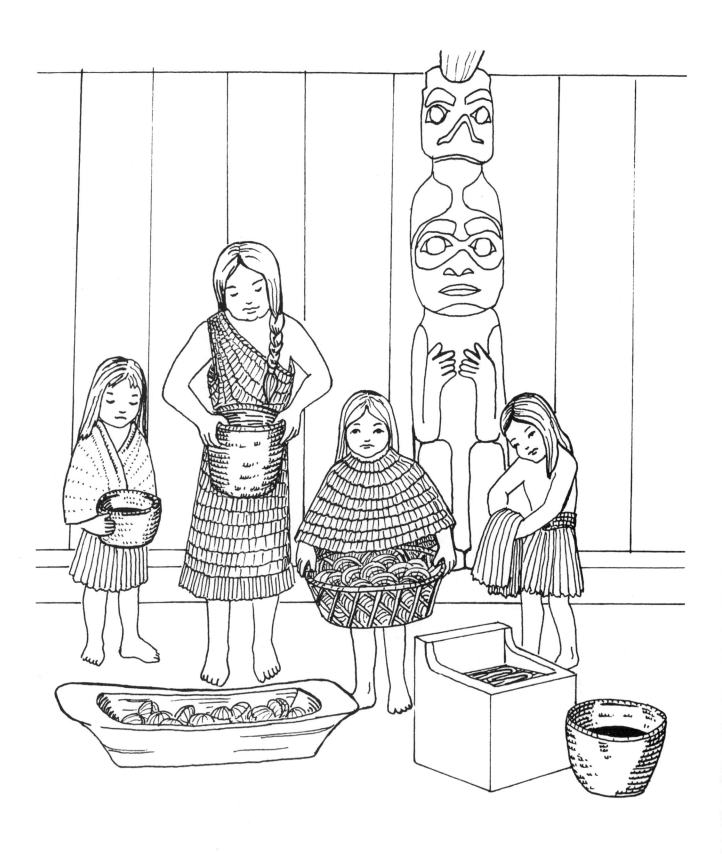

Then Tinka and her mother and her cousins served the clams with fish oil to dip them in.
They passed shredded cedar bark for napkins and spring water to drink.

When everyone had eaten and the scraps were cleared away, Tinka felt very tired. She went to her bed and there she found a wonderful surprise.

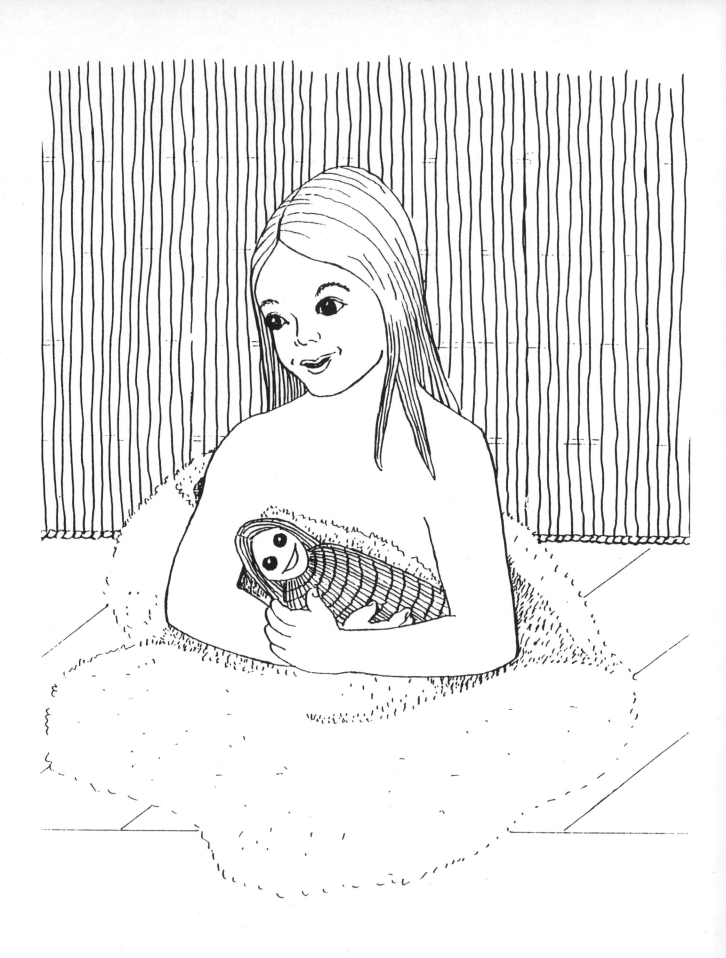

"My very own doll," she laughed. "Thank you, Grandfather," she called. "I knew you would make something wonderful from the whalebone." Then she said to the doll, "I will name you Kawaki."